T0131976

Have You Ever Wished ...

Written By Diane Mondalto

Illustrated By Melanie White

AuthorHouse™
1663 Liberty Drive
Bloomington, IN 47403
www.authorhouse.com
Phone: 833-262-8899

Because of the dynamic nature of the Internet, any web addresses or links contained in this book may have changed since publication and may no longer be valid. The views expressed in this work are solely those of the author and do not necessarily reflect the views of the publisher, and the publisher hereby disclaims any responsibility for them.

This book is printed on acid-free paper.

ISBN: 978-1-4389-4865-2 (sc)

Print information available on the last page.

Published by AuthorHouse 03/17/2021

authorHOUSE®

Dedicated to Jackson Joseph Marshall
and Auntie Roberta.

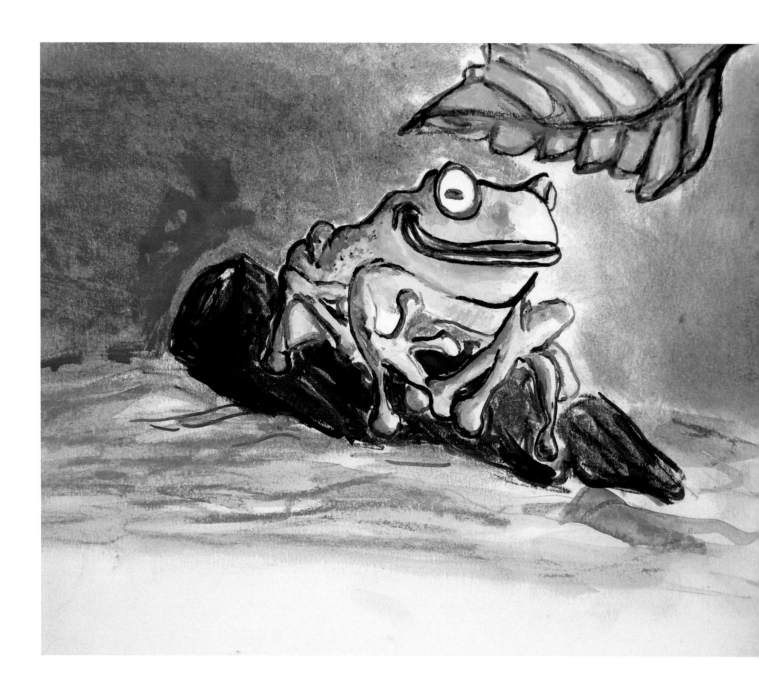

Have you ever wished you were a frog
and you could float atop a log?

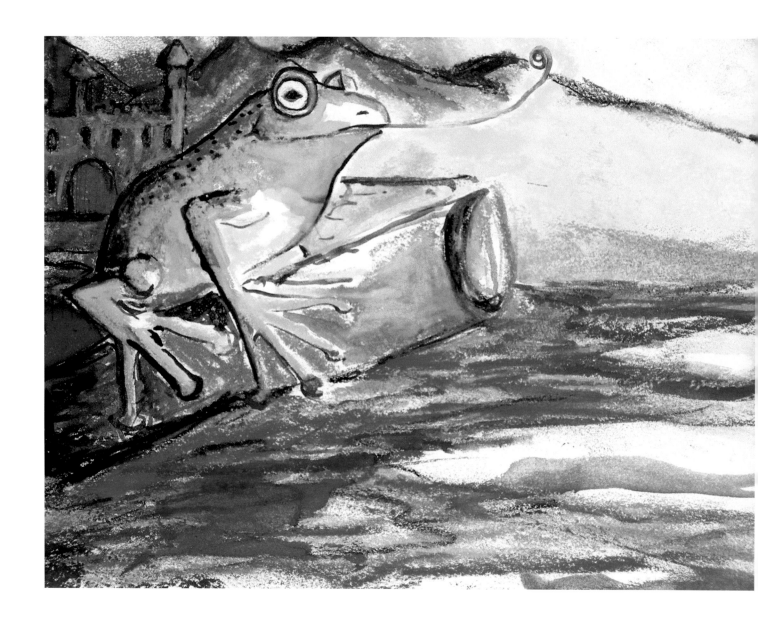

You could float from here to there;
you could float most anywhere.

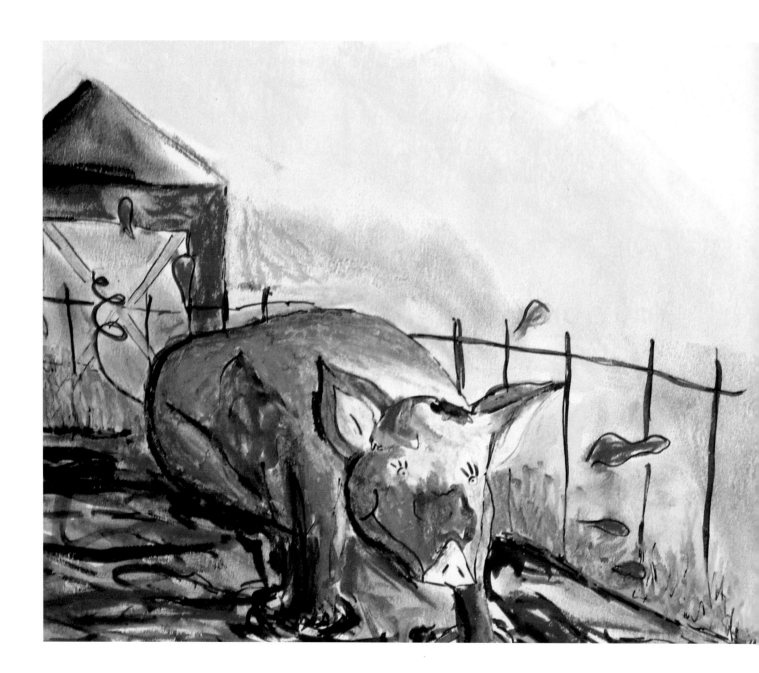

Or maybe you wished you were a pig.
No, not that kind of pig, a pig that digs
the Irish jig.

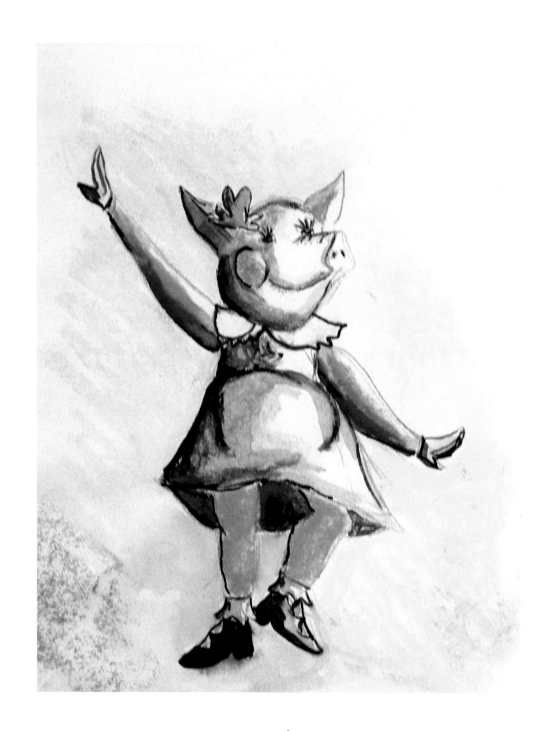

That would be silly, don't you think?
All dressed in green with skin so pink.

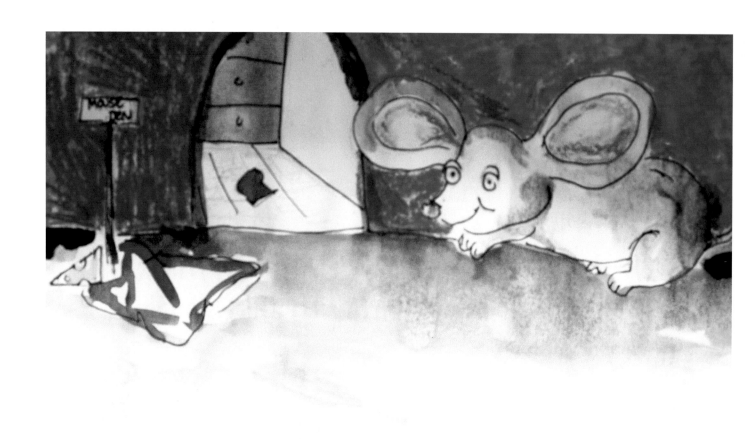

What if you wished you were a mouse—
a mouse that lived in someone's house?

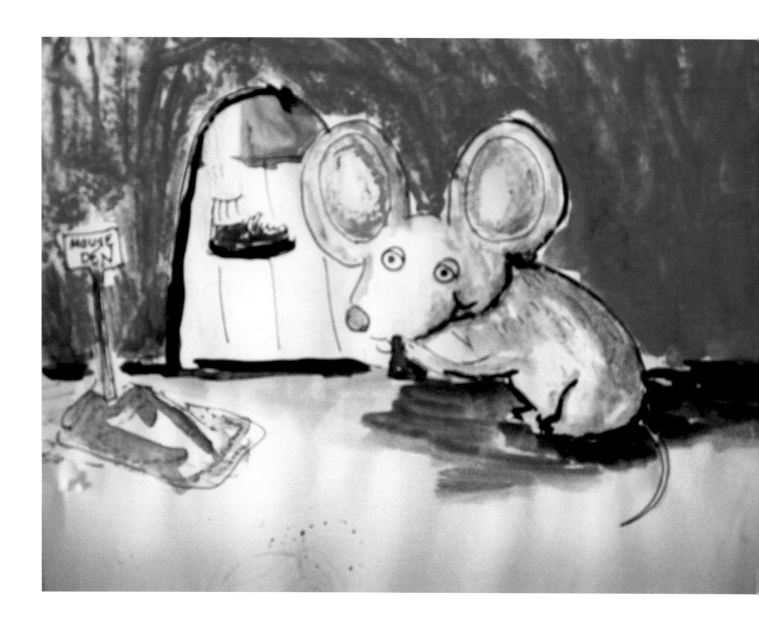

You could poke out your little head
and go exploring for some bread.

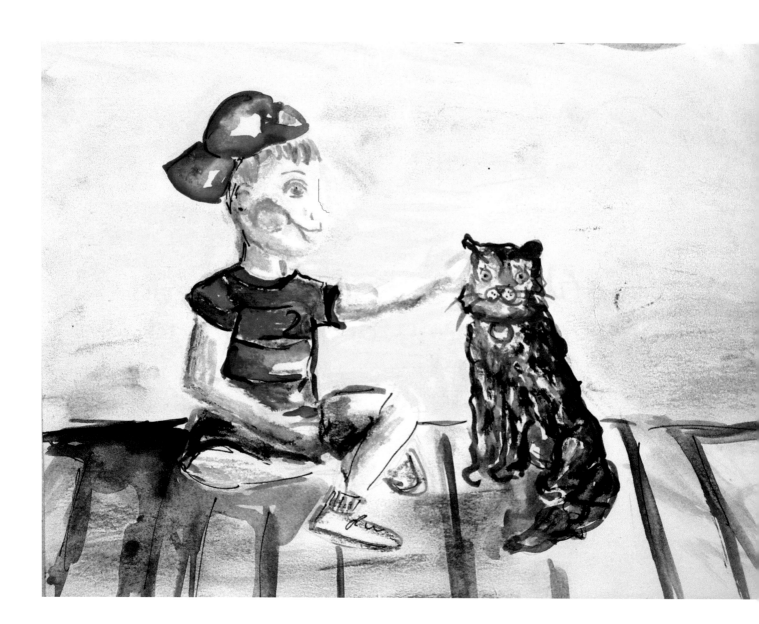

How about if you were a cat
and you could sleep in a hat—

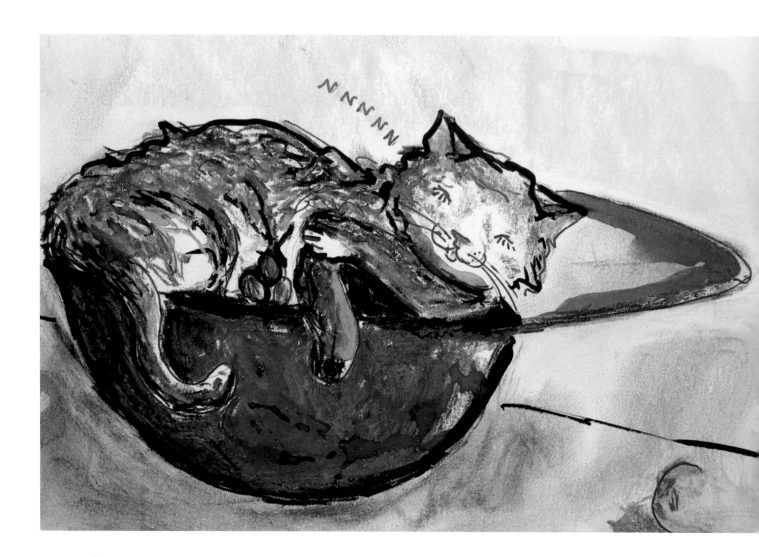

a hat so warm and cozy,
now that is a life that sounds rosy.

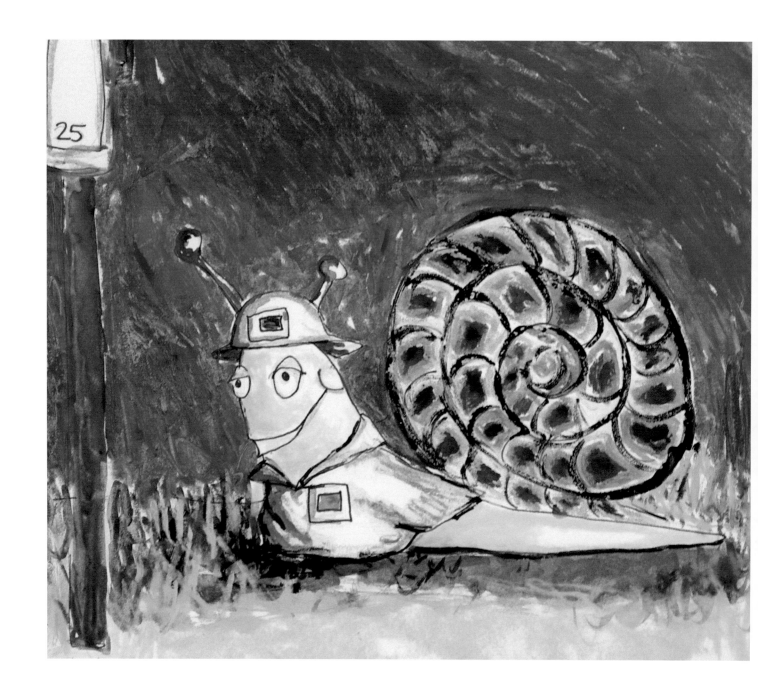

Imagine if you were a snail
and you had to deliver the U.S. mail.

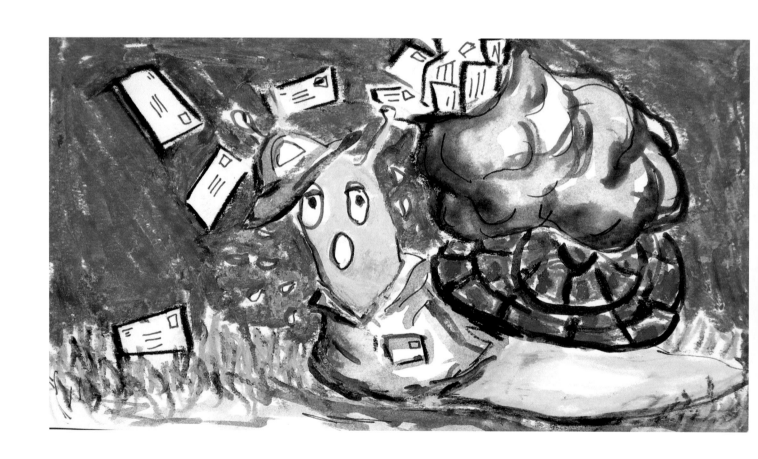

Where would you carry the mail sack?
Not possibly on your little back!

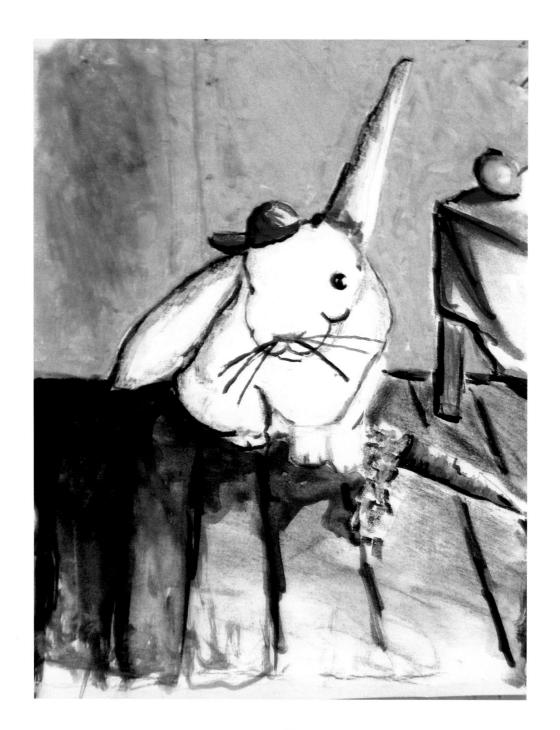

Now here's a good one,
and this one is funny;
what if you wished you were a bunny?

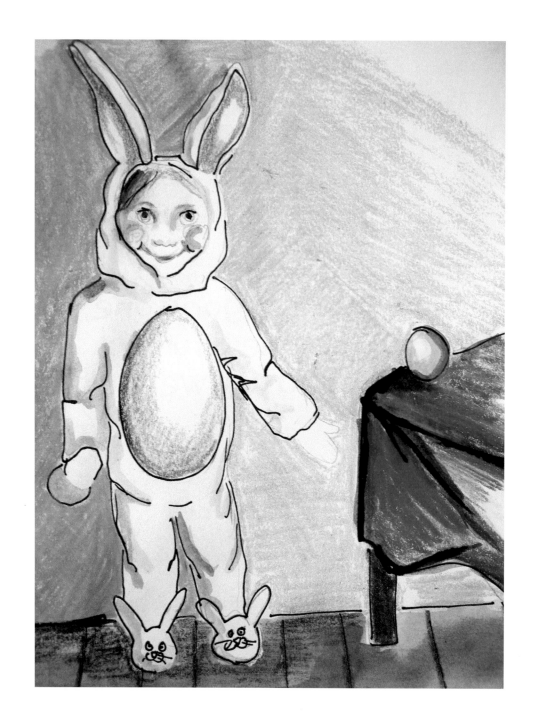

Floppy ears and fur so white,
that would be a funny sight.

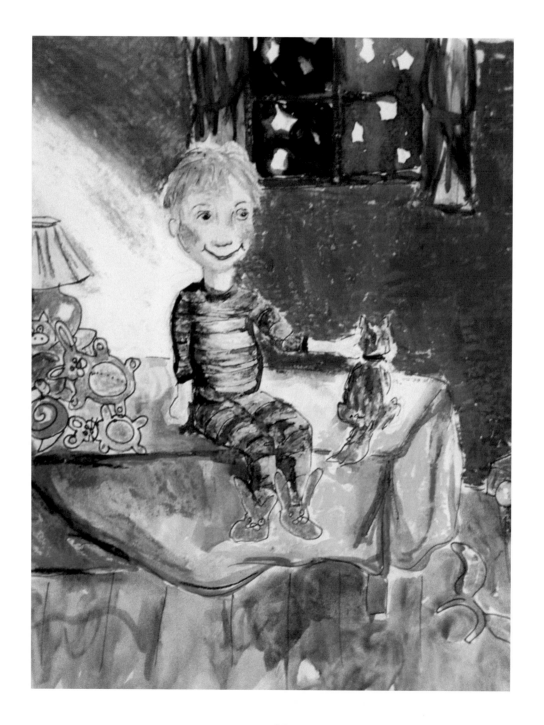

Now we have come to the end,
and you can be yourself again.

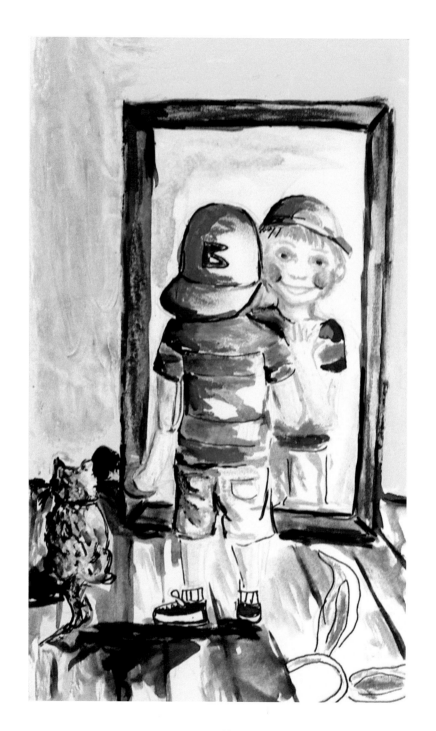

There is no one better, you see,
because you are who you are meant to
be!

Printed in the United States
by Baker & Taylor Publisher Services